Thi...
Please take the time to consider it.

It's a great way to make a
difference.

Thank you.

Warmest regards,

Ewan McGregor

A host of celebrities from around the world have donated their time to create their own personal symbol and message of hope for the future.

Their messages touch on things that affect us all – hope, peace, love, freedom, truth, respect, compassion, children, our planet.

The celebrities' artworks are being used to create Whatever It Takes products for sale worldwide – aiming to raise funds to support key global development causes including poverty alleviation, environmental conservation and the protection of children. Net royalty proceeds go to selected charity projects, including those chosen by the celebrity artist.

Our supporters have made a difference by donating their time, and you can make a difference too by sharing in this project!

Do Whatever It Takes to make a difference!

Fred Salaam Paz
Mir Paz
和 Frieden Mir
Мир
Paix سلام 和
سلام eac
Paz Fred
messages of
Мир 和
Mi eace

peace

Paix 和和 Paceix

Fred Salaam Paz
Fred Frieden
F Salaam Mir
Salaam

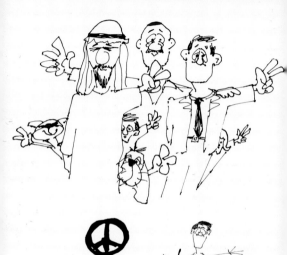

... BY ANY MEANS !

George Clooney

George Clooney

It is an old wish but one we keep even present in our lives as Humans + that is the wish for Peace

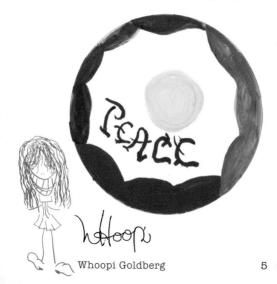

Whoopi Goldberg

5

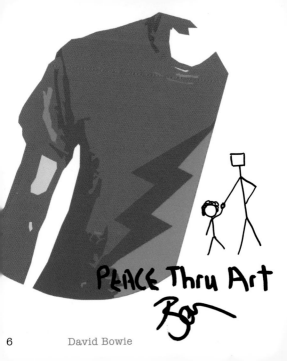

PEACE Thru Art

6 David Bowie

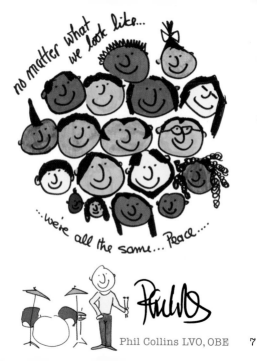

Phil Collins LVO, OBE

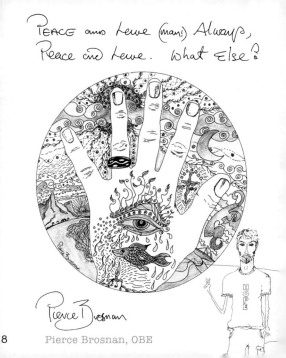

PEACE and Love (man!) Always,
Peace and Love. What Else?

Pierce Brosnan

8 Pierce Brosnan, OBE

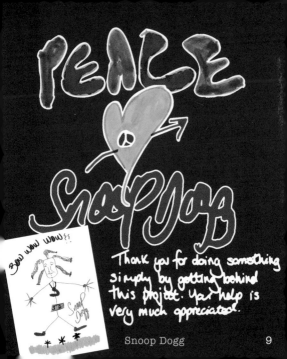

PEACE

Snoop Dogg

Thank you for doing something simply by getting behind this project. Your help is very much appreciated.

Snoop Dogg

9

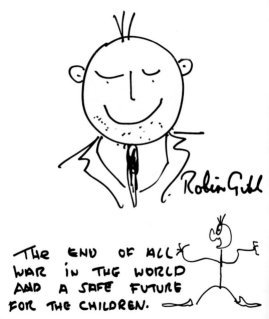

THE END OF ALL WAR IN THE WORLD AND A SAFE FUTURE FOR THE CHILDREN.

Robin Gibb, CBE

10

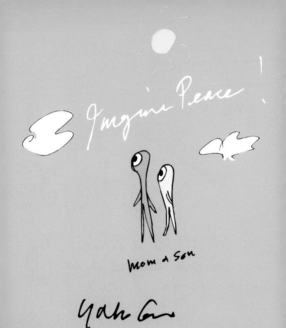

Imagine Peace!

Mom & Son

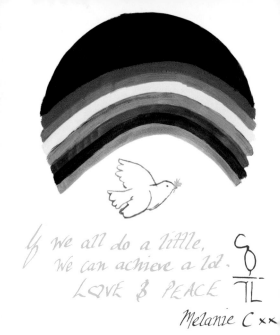

If we all do a little,
we can achieve a lot.
LOVE & PEACE

Melanie C xx

Melanie C

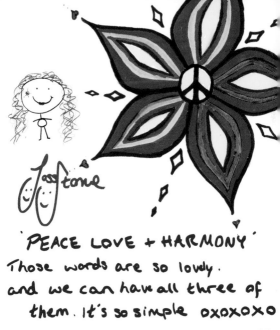

'PEACE LOVE + HARMONY'
Those words are so lovely.
and we can have all three of
 them. It's so simple oxoxoxo

Joss Stone

FEED The World

21

It's O.k. It'll be fine. Things'll turn
out alright just you wait 'n see. Don't
worry. Honestly it's cool. Really. No —
look don't fret. Seriously it'll be great. O.k.?

14 Sir Bob Geldof

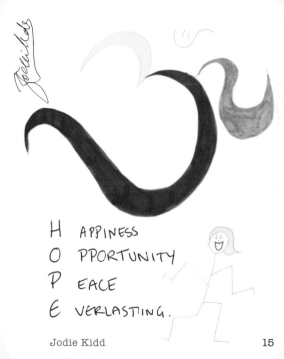

H APPINESS

O PPORTUNITY

P EACE

E VERLASTING.

Jodie Kidd

I HOPE FOR PEACE, TOLERANCE
A BALANCED FUTURE. *Paul Smith*

16 Sir Paul Smit

The tortoise is the symbol
for peace and protection.

Being a mother : I really hope that the
new generation will continue to try to
make a difference and give peace a chance.

Claudia Schiffer

THE LINE THAT COULD.

OPTIMISM IS EVERYTHING. THE DESIRE FOR PEACE AND HAPPINESS CREATES PEACE AND HAPPINESS.

IF ALTERNATIVE MEDICINE WORKS, AND IT DOES SEEM TO, PERHAPS IT'S TIME WE TRIED ALTERNATIVE POLITICS.

18 Billy Connolly, CBE

PEACE, LOVE AND ABOVE ALL KINDNESS
TO OUR FELLOW MAN AND TO ALL THE
CREATURES ON THIS EARTH.

Twiggy Lawson

19

Pro-Natura International – Sustainable Development in Quirimbas, Mozambique

One of the largest problems local communities in Mozambique face is the lack of sustainable economies.

Pro-Natura International has been successfully addressing such problems. Over the past 20 years the organisation has been building sustainable development programmes around the globe, their work earning them much international recognition.

Pro-Natura International, with the help of funds raised by Whatever It Takes, has committed to supporting the Quirimbas National Park Development and Establishment Programme in Mozambique.

The goal of the Programme is to provide local communities with the means to support themselves long-term.

The Programme aims to partner with existing nurseries, which produce native tree seedlings and commercial fruit trees, to facilitate larger scale reforestation.

These Programmes are then expanded to encourage agro-forestry, bee-farming, arts, crafts and eco-tourism, as part of a diversified and balanced development plan. The focus is on preserving and restoring natural resources for long-term economic success.

Such Programmes not only increase the quality of life for these local communities, but give these people livelihoods and the stability to really support themselves and their families. The benefits are many, both for the communities and the environment.

Do Whatever It Takes – make a difference!

messages of
love

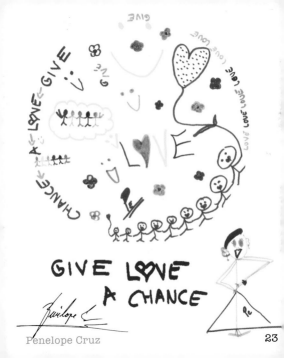

GIVE LOVE
A CHANCE

Penelope Cruz

23

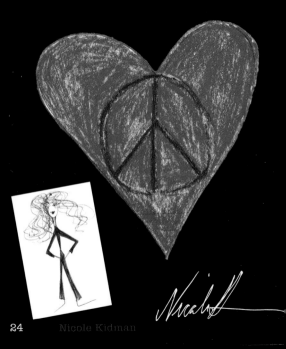

24 Nicole Kidman

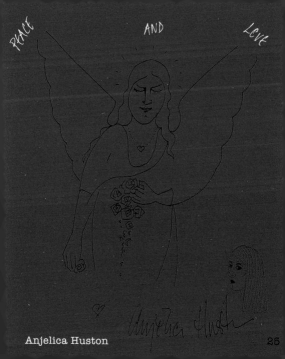

PEACE AND LOVE

Anjelica Huston

25

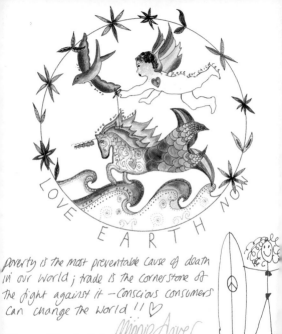

poverty is the most preventable cause of death in our world; trade is the cornerstone of the fight against it – Conscious consumers can change the world !! ♡

Minnie Driver

Minnie Driver

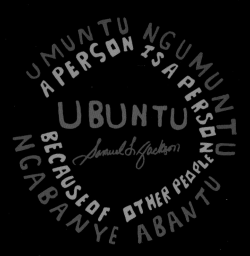

UMUNTU NGUMUNTU
A PERSON IS A PERSON

UBUNTU

Samuel L Jackson

BECAUSE OF OTHER PEOPLE

NGABANYE ABANTU

I HOPE THE PRINCIPLE OF UBUNTU
BECOMES THE WORLD'S PASSWORD.
LOVE OF SELF LEADS TO LOVE OF ALL.

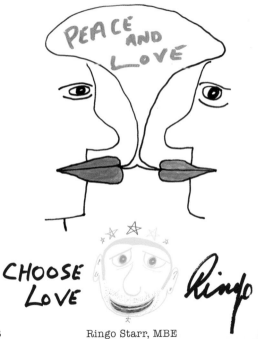

28

Ringo Starr, MBE

Love is the message + the message is love

Arthur Baker

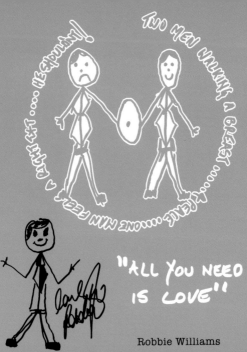

"ALL YOU NEED IS LOVE"

Robbie Williams

LOVE OPENLY.

Ana Matronic

31

Will Young

ALL HEARTS BEAT AS ONE!

Charlize Theron

Forgiveness is the name of love practised among people who love poorly. The hard truth is that all of us love poorly. We need to forgive and be forgiven every day, every hour unceasingly. That is the great work of love among the fellowship of the weak that is the human family.

Henri Nouwen
Henri Nouwen

Susan Sarandon

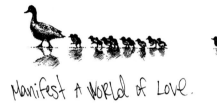

Manifest A World of Love.

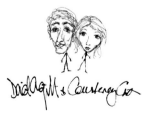

David Arquette + Courtney Cox

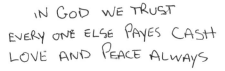

IN GOD WE TRUST
EVERY ONE ELSE PAYES CASH
LOVE AND PEACE ALWAYS

WINK
FOR
PEACE

Ozzy Osbourne

LOVE · TRUTH · RESPECT ·
COMPASSION · PATIENCE · TRUST

Toni Collette

37

"LOVE"
(I KNOW ITS A CLICHE)

Mike Skinner, The Streets

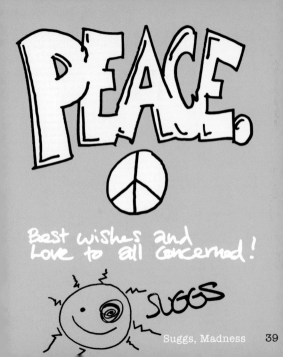

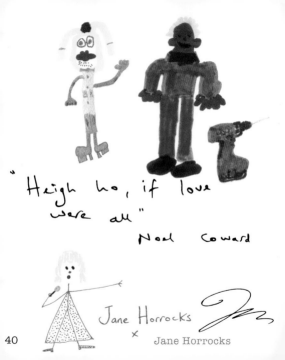

"Heigh ho, if love were all"

Noel Coward

Jane Horrocks

Jane Horrocks

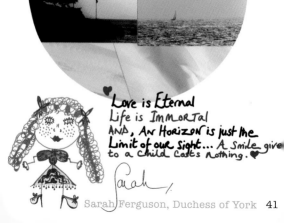

♥ Love is Eternal
Life is Immortal
AND, An Horizon is just the
Limit of our sight... A smile give
to a child costs nothing. ♥

Sarah

Sarah Ferguson, Duchess of York 41

Bringing Love....

Homebased care project in Mozambique

In Mozambique there are more than 270,000 orphaned children, mainly through HIV/AIDS.

For most children, losing a parent is tragic enough, but for children such as those in Zambezia and Mozambique, it can often be just the tip of the iceberg.

For these children, losing a parent can mean losing a lot more – access to food and their livelihood, which in turn can lead to malnutrition, illness, and lack of opportunities such as education – in brief, access to a future.

Homebased care projects such as those run by UNICEF and Save the Children can bring much needed support and love to these children. The practical support provided by these charities can make it easier for them to come to terms with their loss.

Monies from Whatever It Takes are making a difference to the lives of orphaned children in the following ways.

Prolonging the life of the parent, in comfort, means that important issues affecting the child's future welfare can be dealt with.

These include passing down farming knowledge, so children can continue to grow food; consulting with the children on future living arrangements; discussing how land and belongings should be distributed, reducing land-grabbing; providing food baskets with essential supplies; preparing the child emotionally for the passing of their parent.

All of the above reduce the child's vulnerability, giving much needed stability and in many cases assuring a future that they may otherwise not have had.

Do Whatever It Takes – make a difference!

messages of
hope

44

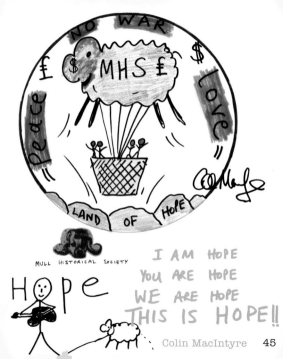

Colin MacIntyre 45

Words from the poem
"Stanzas on Freedom"
by James Russell Lowell (1819-1891)

TRUE FREEDOM IS TO SHARE / ALL THE CHAINS
OUR BROTHERS WEAR, / AND, WITH HEART AND HAND
TO BE / EARNEST TO MAKE OTHERS FREE !

Fiennes

Study of an Apostle's Hands, 'Praying Hands',
preliminary study of the Heller Alter, c. 1508.
Albrecht Dürer,
1471-1528

A 21ST CENTURY LEADER — IS A DEALER IN HOPE.
AND HOPE IS A WAKING DREAM!

46 (SO... KEED US AWAKE!) Joseph Fiennes

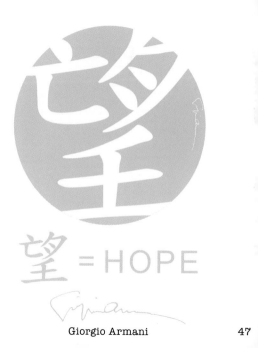

望 = HOPE

Giorgio Armani

Goldfinger

My Hope for the future.
is that we will see the end
of Famine in the World

48 Dame Shirley Bassey

FREEDOM

Hope is a good thing.

Morgan Freeman

HAppiness
On
Planet
Earth

Stella McCartney

♪ ♫ + ⚛ + LOVE ♥ ✦
= Hope for the future!

Music + peace and love = hope
for the future!

Bless You,

Ronnie Vannucci 51

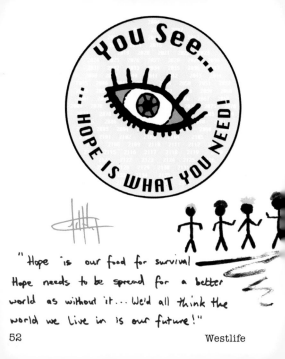

You See...

... HOPE IS WHAT YOU NEED!

"Hope is our food for survival. Hope needs to be spread for a better world as without it... We'd all think the world we live in is our future!"

52 Westlife

IT'S ONLY THE FEARS OF A GOOD START

Happy Days.

Hope this helps,
Hope it makes a difference
Hope, Hope, Hope.

Ewan McGregor 53

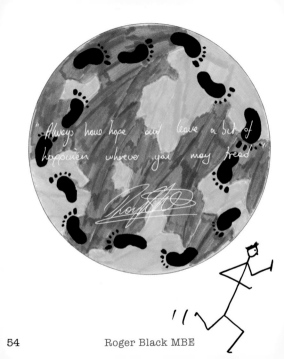

"Always have hope and leave a bit of happiness wherever you may tread."

54

Roger Black MBE

Family

When others don't believe in you, your destiny is challenging
you to believe in yourself. Life is asking you to pay for what
you're asking. If its saying, "How bad do you want it?" If in these
moments you can believe more in your hopes than your insecurities you
will advance. You will keep moving closer to your dream.

Linford Christie

55

Vision without action is nothing but a daydream. The children are the future. They look to for love and support. Let's always give them hope.

56

Lucy Liu

May football unite and put
smiles on the faces of the
world through hope and peace.

Gianluca Vialli

I HOPE THAT YOU ARE WELL & IF YOU AREN'T I HOPE THAT YOU GET BETTER

xx Jarvis

Jarvis Cocker

Not Matter what there is always hope. Bad weather, Awful infact, along with falling rocks, DISASTER. Yet the sun popping out in the corner with the pretty stream, symbolises HOPE!

Harry Judd, McFly

59

My hope is that eventually
a generation will learn from
the mistakes of the past & they will not
be repeated. Then & only then is there
hope for peace & love for all.!!

Martina

Martina Navratilova

sharing, trying to understand each other, forgiving is the only way forward

Paloma Picasso

Paloma Picasso

Bringing hope....

School Construction Project - Mazivela, Mozambique

Basic education is vital in creating a sustainable community and equipping children for the future.

Some communities face not just a shortage of qualified teachers and materials, but also basic classrooms to teach in.

Whatever It Takes has made a difference by funding the Mazivelan School Construction Project in Mozambique, run by Child Fund International.

Before the project, children and teachers were using mud and woven reed classrooms, with makeshift zinc roofs. Not only were these unsafe, but after heavy rains they had to be rebuilt by parents.

Lack of furniture meant that children sat on the beaten earth floor, making learning to write very difficult. It was also impossible for teachers to store learning materials in the classroom.

Monies raised through Whatever It Takes have helped the community build a two-room school with teacher's office.

The School Construction Project has not only improved the learning environment of the community, it has made it safer, more productive and given young people the opportunity to learn basic building skills.

The project has made a huge difference to the lives of over 200 children and their families in Mazivela.

Do Whatever It Takes – make a difference!

messages for the

future

Become friends today with the person you
dislike the most. Contact them — befriend them.
You'll surprise yourself.

Peace, Justice, progress and
solidarity for all in this
<u>XXI</u>st century

His Majesty The King of Spain

HOUSE MUSIC

"The world needs a remix"

SHAPESHIFTERS

The Shapeshifters

THE SUN, THE MOON, THE STARS...
YOU, ME, AND ALL OF US COME
TOGETHER TO CREATE THE UNIVERSE...
TOGETHER!!!

68 Darryl McDaniels, Run DMC

Smile Today.
Life is not a rehearsal.

Sir Michael Caine, CBE & Lady Shakira Caine **69**

WE ALL HAVE HANDS TO HELP OTHERS

Sir Roger Moore

We're in this together

Mick Hucknell, Simply Red

I'D LIKE TO THANK TRADE PLUS AID & 21ST LEADERS
FOR CREATING AN ORGANIZATION WHOSE AIM IS TO
MAKE A POSITIVE DIFFERENCE TO THE ISSUES OF
CHILD ABUSE AND OUR ENVIRONMENTAL PROBLEMS

Annie Lennox

THE PEN AND LOVE WILL ALWAYS BE MIGHTIER THAN THE SWORD OF HATE.

Each generation thinks "There is nothing more to do." Wrong. It is always possible to make this world a little better before we leave it.

Frederick Forsyth

Frederick Forsyth, CBE

Om Mani Padme Hum.

The Mantra of Compassion.

Richard Jones, The Stereophonics

With organizations like this
we can really "make it through
the rain"

Barry Manilow

WORLD POLITICS BEGINS WITH THE PERSON NEXT TO YOU.

Sir Ben Kingsley

76

Look after our animals
So our children can
see them !!!

RW

I would like everyone to do the
most sensible things, which are quite
obvious to save the earth, as we now
know it – but we wont if people
don't listen and observe !! GO-EAT
ORGANIC!

Ronnie Wood

to the future!

Tim Wheeler, Ash

Make a difference, it starts with you ♡

Heidi Klum

WE ARE FAMILY

D. Tutu

80

Archbishop Desmond Tutu

NOW OR NEVER

David Bailey, CBE

81

WORLD

PASSPORT

Type
P

Issuing Country
JPN

Passport No.
NH0123456

Surname
NAKATA

Given name
HIDETOSHI

Nationality
JAPAN

Date of birth
22 JAN 1977

Sex
M

Registered Domicile
TOKYO

Date of issue
22 JAN 2005

Date of expiry
22 JAN 2015

Signature of bearer
中田英寿

NO LINE, NO LIMIT,
EVERYTHING BECOMES ONE!

82

Hidetoshi Nakata

SAVE OUR WORLD

Gary Linekar

We have the freedom to be ourselves, our real selves, here and now, and nothing can stand in our way.

Richard Bach

Live long and PROSPER. x

Justin Hawkins

85

LOVE CHOCOLATE
FOOTBALL U2
FAIR TRADE
JONNY GUY HILL
KIDS SURF
RADIOHEAD
SEX (KATE WEIGERT) INTEGRITY
KEN NELSON HAPPINESS MANDELA TREES WATER
(ROBERT TO BENISON) ANTHONY HICKIN'S LIFE IS BEAUTIFUL
PIANOS BOB SUPPORT WATER AID PEACE GUITARS MAGIC
NEXT U 5 ELECTIONS HOPE SO FEAR STORM THE OFFICE
SIMON PEGG AND NICK FROST ASH EMBRACE CLEAN EARS
BLUES VICKI TAYLOR JONNM'S SOLO ON 42 GUYS PICTURES
ALAN PARTRIDGE
A A A K E N M
YOGA YODA YOGI
BEAR YOGHURT DRINK
GIVE YOUR GHOST?
THE MILK MACBETH
CAKE BREAD
AND MOST OF ALL
G . K . & £ 1 . BO

POSITIVE

= NEGATIVE

MUSIC

make trade fair . com
= WaterAid . org

C A J MARTIN
W CHAMPION
G BERRYMAN
J BUCKLAND

86 Coldplay

"THE WORLD WORKING TOGETHER,
CAN ACHIEVE SO MUCH MORE"

Sir Steve Redgrave

Building a Better Future...

Kampot Traditional Music School

Founded in 1994 by Catherine Geach, a concert violinist and humanitarian, The Kampot Traditional Music School for orphaned and disabled children is a very special one.

The school is located in the area of Khmer Rouge, Cambodia, an area severely affected by AIDS, extreme weather conditions and until the late 90's, war. Droughts in the dry season and floods in the rainy season, in turn, seriously affect food supplies and local utilities such as running water and electricity.

Many children attending the school have already endured severe traumas, the loss of their parents, acute ill-health, malnutrition, abuse and in some cases being sold into slavery. Many of these children are so poor that without the school's help, they would be excluded from further state-system education and would already be working in the salt fields.

Through the use of art, music and dance and a programme of dedicated, loving care, these young children can restore their trust and confidence and find a positive path to a better future.

The quality care and counselling these young children receive takes them from these early stages, to making educational choices of their own, right through to becoming young adults, graduating and themselves integrating into society.

At any one time, the school offers residential care for 30 orphaned children, as well as assisting local children with their studies and providing hot meals and medical care to children that need it.

Catherine Geach's love and dedication and belief in the healing powers of music has already helped the lives of so many.

Do Whatever It Takes – make a difference!

WhateverItTakes.org is proud to help support the following charities:

Save the Children

Lifebeat

Spirituality for [

Lifeline

Trade plus Aid

International Federation of
Red Cross & Red Crescent
Societies

Band Aid

Tooth Fairy Foundation

Starfish

UNICEF

Sharon Osbourne Col
Cancer Programme

Comic Relief

Adopt-A-Minefield

Nelson Mandela
Children's Fund

WaterAid

Children of the Andes

Virgin Unite

Anti-Slavery International

Greenpeace

Campaign to End Fistula

Brit Trust

90

Pro Natura

CARE International

Healthlink Worldwide

S.A.F.E.

Heifer International

World Neighbours

Great Ormond Street
Hospital Children's Charity

Lotus Outreach

Kampot Music School

enage Cancer Trust

Child Fund International

Rights and Humanity

Holy Apostles
Soup Kitchen

xfam International

Little Dreams
Foundation

St. Jude Children's
Research Hospital

Breast Cancer
Campaign

Tusk

Dreams Can Be Foundation

Children's Medical
Research Institute

And here are some simple (and fun!) ways you can make a difference!

Cycle to work – great for you and the environment!

Recycle by signing up to cool websites like **www.freecycle.org** and **www.bookcrossing.com** and give stuff you don't want to those that do

Hang out your washing instead of tumble drying – smells nice and fresh and saves electricity